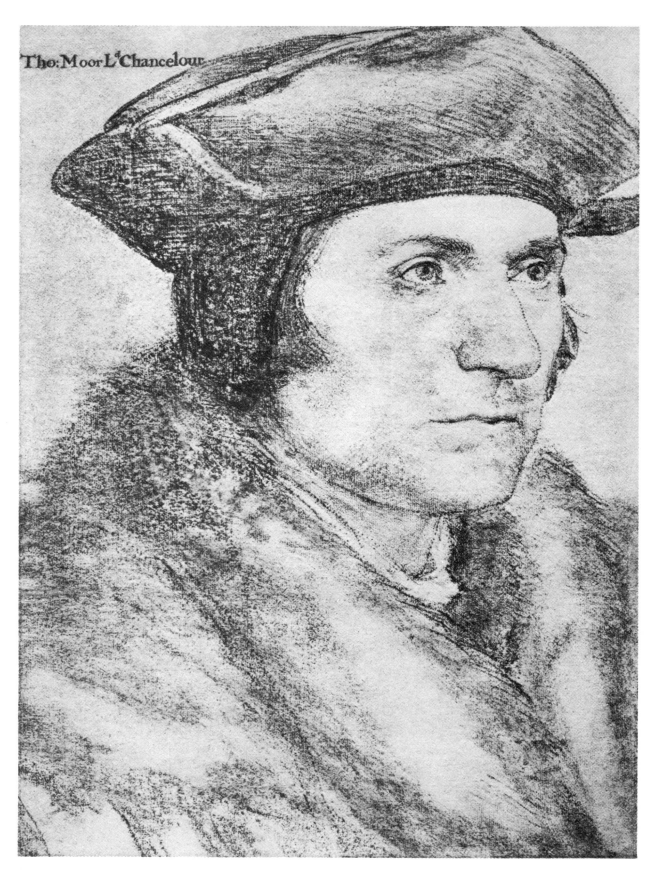

Tho: Moor Lᵈ Chancelour

SIR THOMAS MORE (1477/78–1535). Humanist; author of *Utopia*; Lord Chancellor; executed 1535; canonized 1935. 397 × 299 mm.

HOLBEIN
Portrait Drawings

44 Plates by Hans Holbein the Younger

Dover Publications, Inc., New York

PUBLISHER'S NOTE

Hans Holbein the Younger was born in Augsburg in 1497/98. His father, himself an important artist, provided him with his grounding. In about 1515 Holbein went to Basle, where he moved in humanist circles, painting portraits and religious themes and executing woodcuts for books, the most notable being those for *The Dance of Death* (Dover 22804-5). He also made trips to France and Northern Italy. In 1526, when the increasing conflict of the Reformation made the climate of Basle more restrictive, Holbein went to England by way of the Low Countries, bearing with him a letter of introduction to Sir Thomas More from Erasmus. Holbein returned to Basle in 1528, but even the presence of his wife and two children could not keep him there; he returned to England in 1532 and was quickly taken up by the court of Henry VIII.

The fickle monarch had complete faith in Holbein's abilities, going so far as to send him abroad to make portraits of prospective brides for his examination. Holbein designed extensively for the court, from jewels and robes to seals and swords, establishing the "look" we associate with it. The great artist died of plague in 1543.

Holbein's record of one of the world's most brilliant and tempestuous courts, in drawings and finished portraits executed with inimitable sensitivity and impeccable draftsmanship, is unique in the annals of history and

of art. Here is one of the great lights of the age, Sir Thomas More, as well as his nemesis, the totally unscrupulous Richard Rich. Here is Jane Seymour, whose early death the king lamented all his days. Henry Howard, Earl of Surrey, a brilliant poet whose career was abruptly ended by the headsman's ax, is also depicted, as are sitters whose identities have been lost entirely or are subject to conjecture.

Although most of the drawings were preparatory for finished paintings (few of which have survived), most were intended as a reference only. None has been squared off and only one in this volume, that of Sir Thomas More, has been pricked for transfer.

Before being added to the collection of the Royal Library, Windsor, the drawings passed through many hands and were consequently subjected to much handling and wear. Many were "touched up" by later hands. The written identifications of the subjects, sometimes spurious, are also later additions. Holbein's own notations on the drawings refer to color.

The captions provide, when data were available, the identification, dates and brief description of the subject, and the drawing's dimensions in millimeters. The drawings were executed on pink prepared paper in black and colored chalks. The use of additional media is noted in individual captions.

Copyright © 1985 by Dover Publications, Inc.
All rights reserved under Pan American and International Copyright Conventions.

Published in Canada by General Publishing Company, Ltd., 30 Lesmill Road, Don Mills, Toronto, Ontario.
Published in the United Kingdom by Constable and Company, Ltd.

This Dover edition, first published in 1985, is a selection of works reproduced in *Iohann Holbein / Le Livre de Portraits / à Windsor Castle / Choix de Cinquante Dessins / en Fac-similé*, second edition, published in 1927 by Braun & Cie., Editeurs d'Art, Paris, as the second volume in the first series of *Dessins et Peintures des Maîtres Anciens*. A new Publisher's Note has been written specially for the Dover edition. The captions draw heavily upon *Holbein and the Court of Henry VIII*, The Queen's Gallery, Buckingham Palace, London, 1978–1979.

The publisher would like to extend his thanks to the University of Cincinnati Library for making its copy of *Iohann Holbein* available for reproduction.

Manufactured in the United States of America
Dover Publications, Inc., 31 East 2nd Street, Mineola, N.Y. 11501

Library of Congress Cataloging in Publication Data

Holbein, Hans, 1497–1543.
 Holbein portrait drawings.

 (Dover art library)
 1. Holbein, Hans, 1497–1543. I. Dover Publications, Inc. II. Title. III. Series.
NC251.H65A4 1985 741.943 85-6804
ISBN 0-486-24937-9

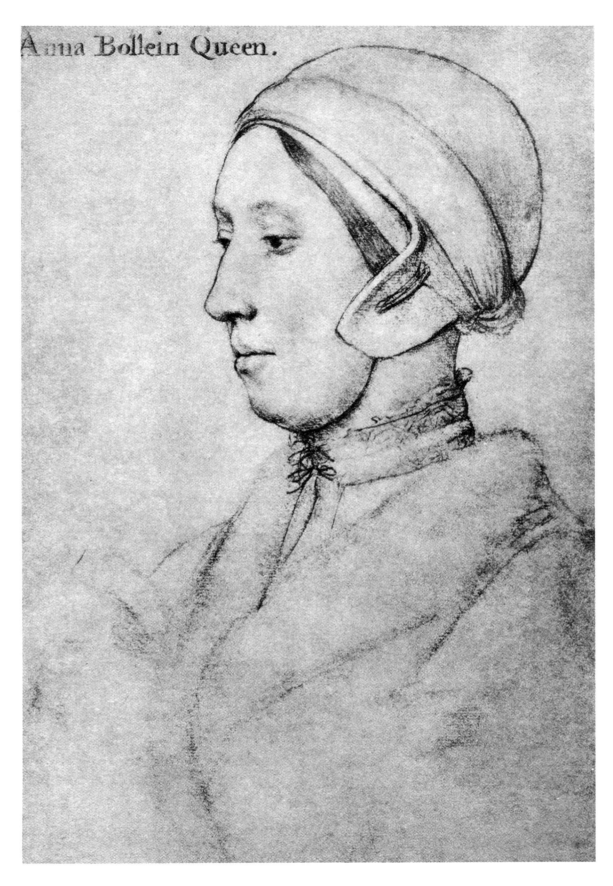

Anna Bollein Queen.

UNKNOWN LADY (also identified as Anne Boleyn). 281 × 192 mm.

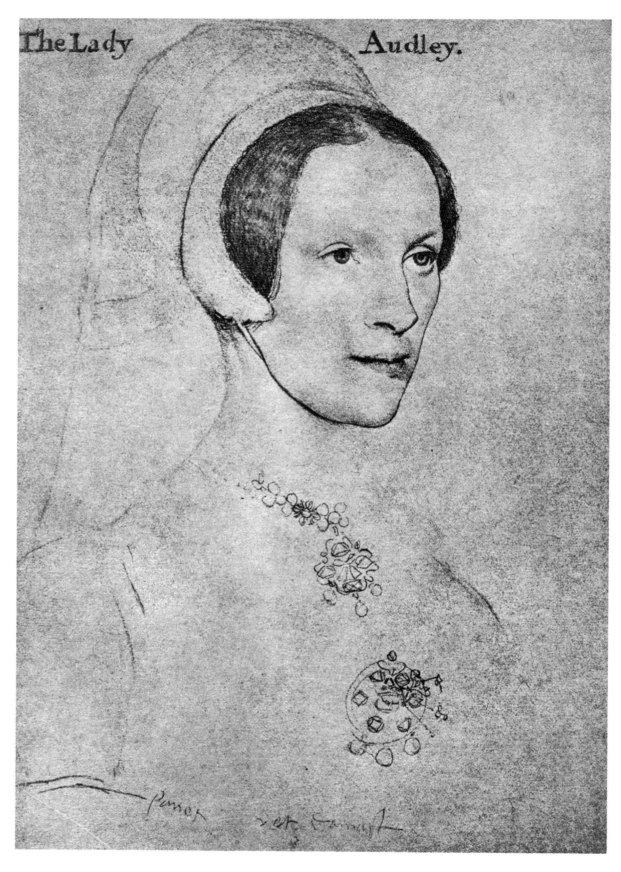

? ELIZABETH, LADY AUDLEY (d. before 1564). Wife of Thomas, Lord Audley of Walden. 292 × 207 mm. Jewelry and notations at bottom in metalpoint; pen-and-ink reinforcement of outlines.

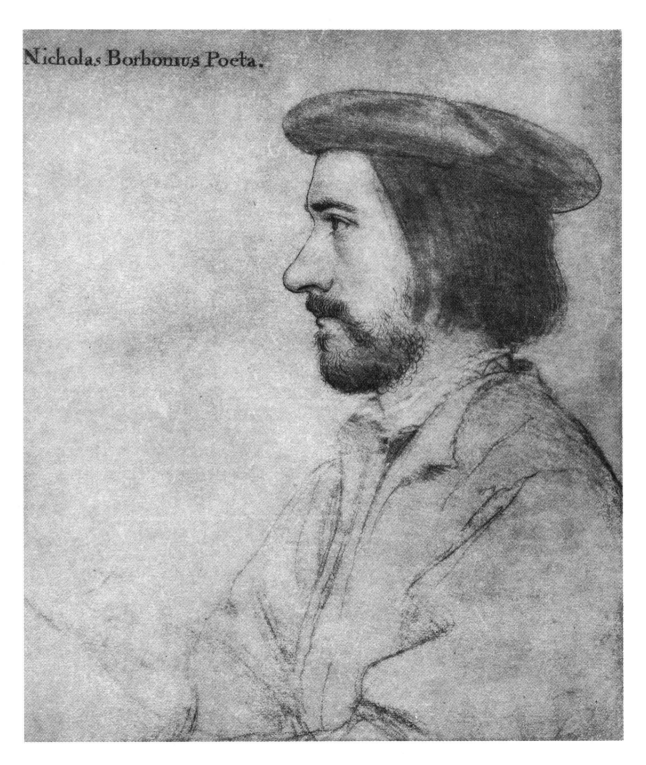

NICHOLAS BOURBON THE ELDER (1503–after 1550). Humanist poet; author of *Nugae*; 307 × 257 mm. Pen-and-ink reinforcement.

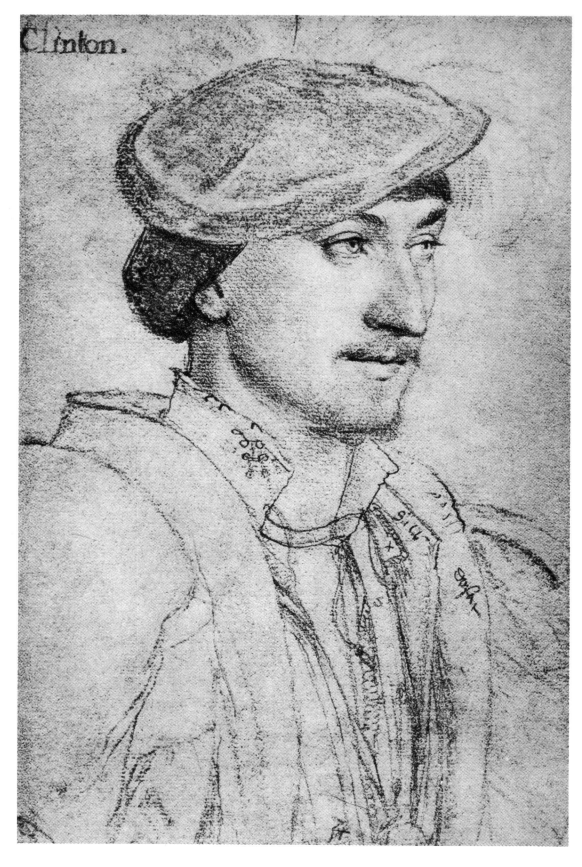

EDWARD, 9TH BARON CLINTON (1512–1585). Lord High Admiral to
Edward VI and Elizabeth I; Earl of Lincoln. 218 × 144 mm. Pencil rein-
forcement on mouth; metalpoint on costume.

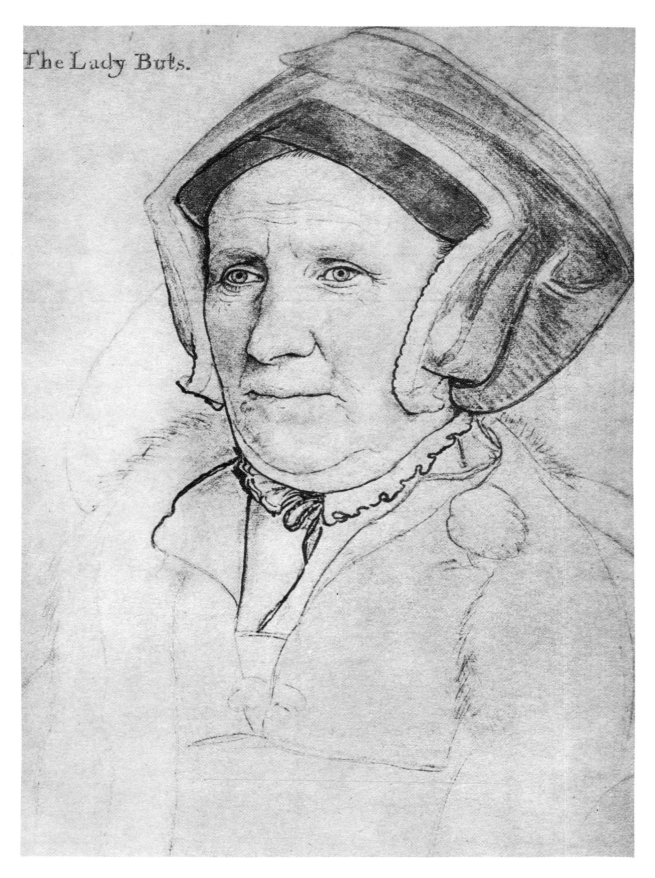

The Lady Buts.

MARGARET, LADY BUTTS. Wife of Sir William Butts, physician to Henry VIII;
lady-in-waiting to Princess Mary. 377 × 272 mm. Pen-and-brush ink reinforcement; metalpoint.

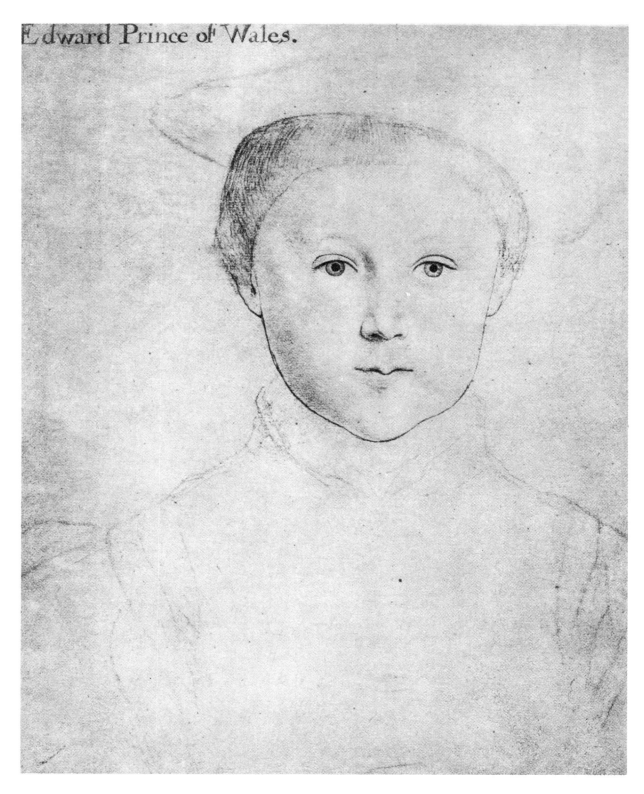

EDWARD, PRINCE OF WALES (1537–1553). Son of Henry VIII and Jane Seymour; later Edward VI.

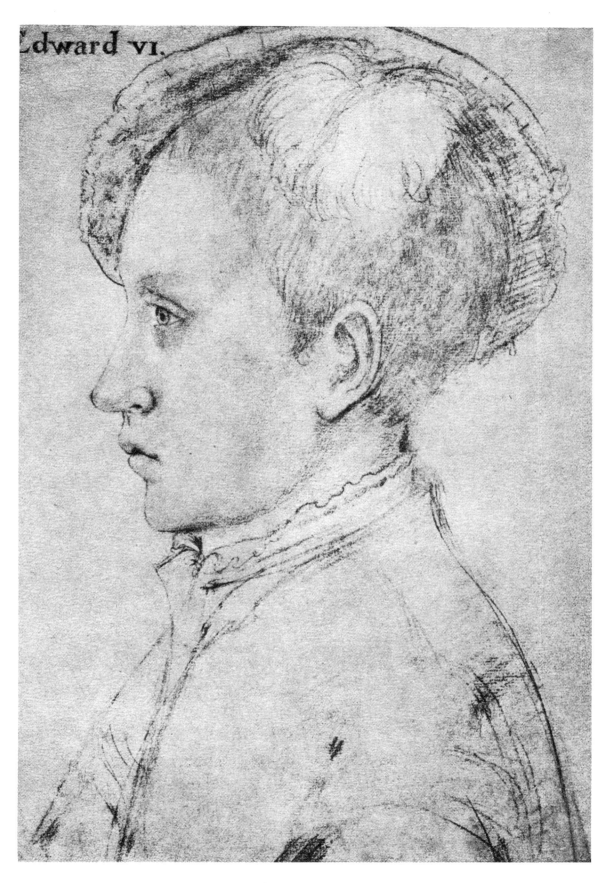

? EDWARD VI.

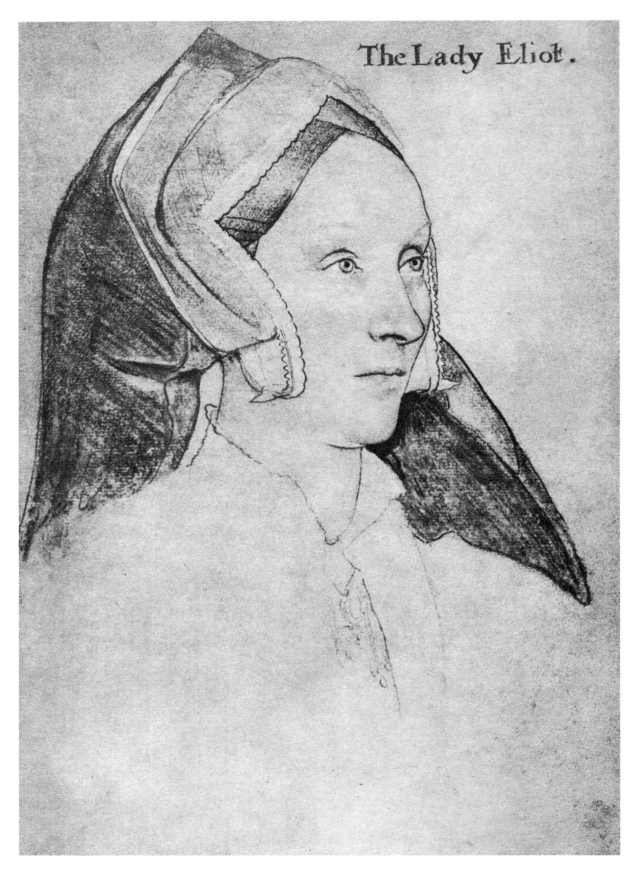

The Lady Eliot.

MARGARET, LADY ELYOT (d. 1560). Wife of Sir Thomas Elyot. 278 × 208 mm.
Ink strengthening; some body-color heightening.

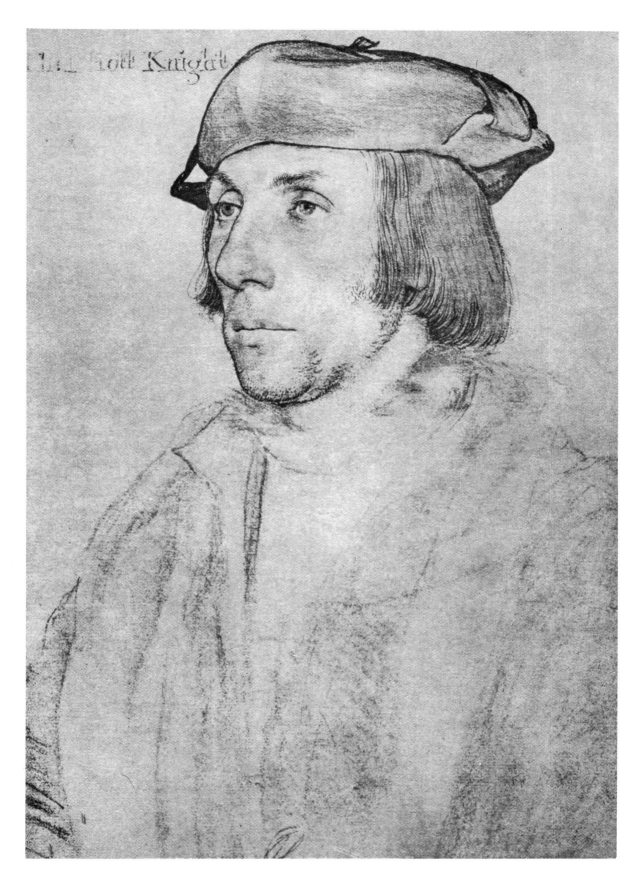

SIR THOMAS ELYOT (before 1490–1546). Lawyer; friend of Sir Thomas More; ambassador to the court of Charles V. 284 × 205 mm. Some ink strengthening of outlines; eyes heightened in white.

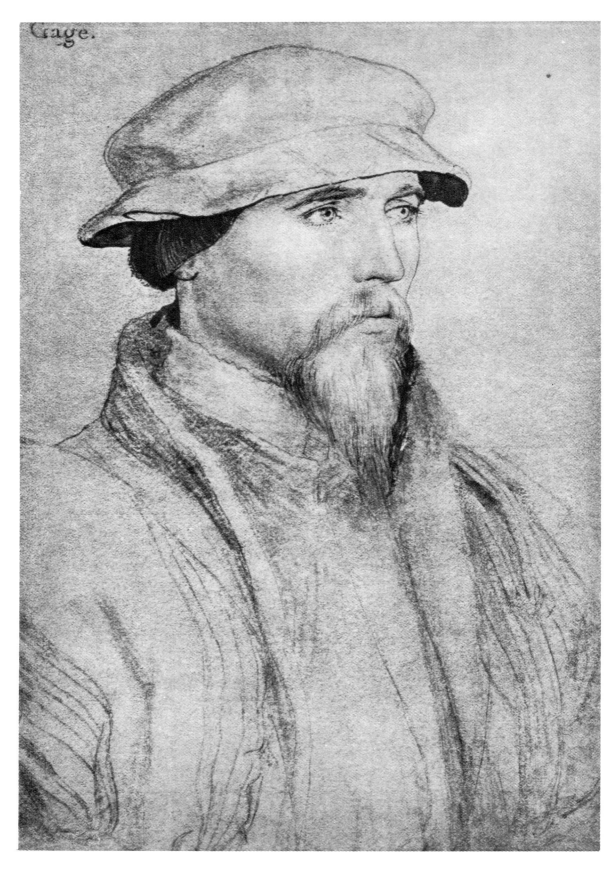

SIR JOHN GAGE (1479–1557). Governor of Guisnes; Comptroller of Calais;
Vice-Chamberlain to Henry VIII; Lord Chamberlain. 394 × 289 mm. Pen-and-
brush ink reinforcement; metalpoint on gown.

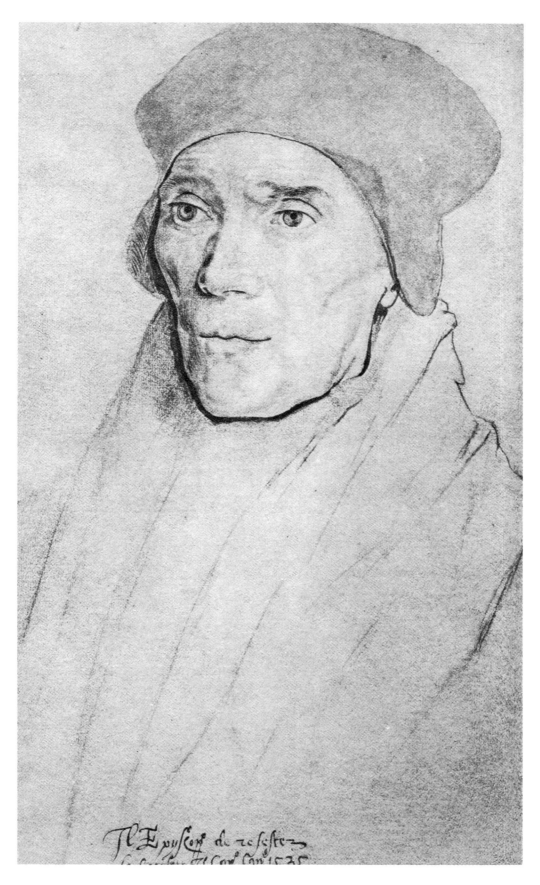

JOHN FISHER, BISHOP OF ROCHESTER (1469–1535). Friend of Erasmus;
Chancellor of Cambridge University; executed 1535; canonized 1935.
382 × 232 mm. Pen-and-brush ink reinforcement; some watercolor wash.

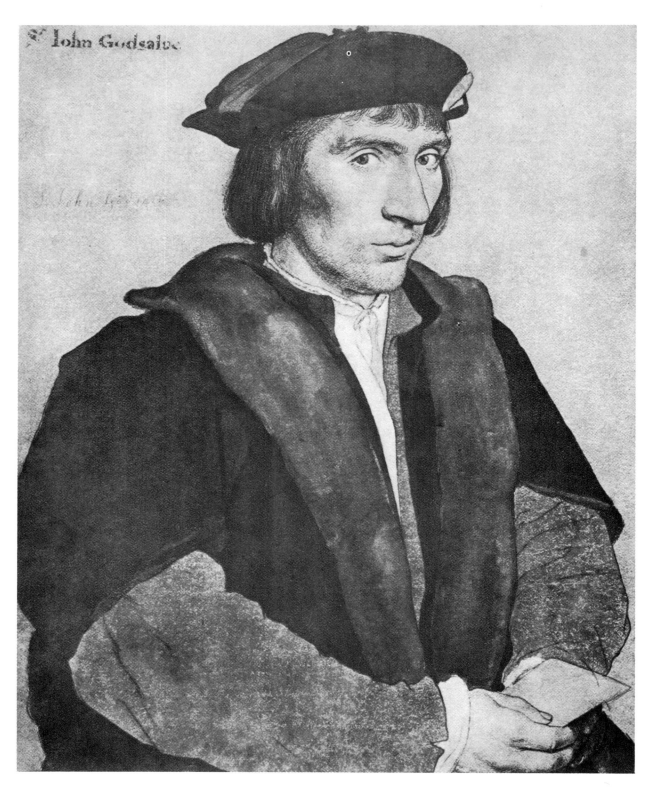

S^r Iohn Godsalve

SIR JOHN GODSALVE (ca. 1510–1556). A deputy to Thomas Cromwell; Comptroller of the Royal Mint. 361 × 291 mm. Watercolor, body color, pen-and-brush application of ink.

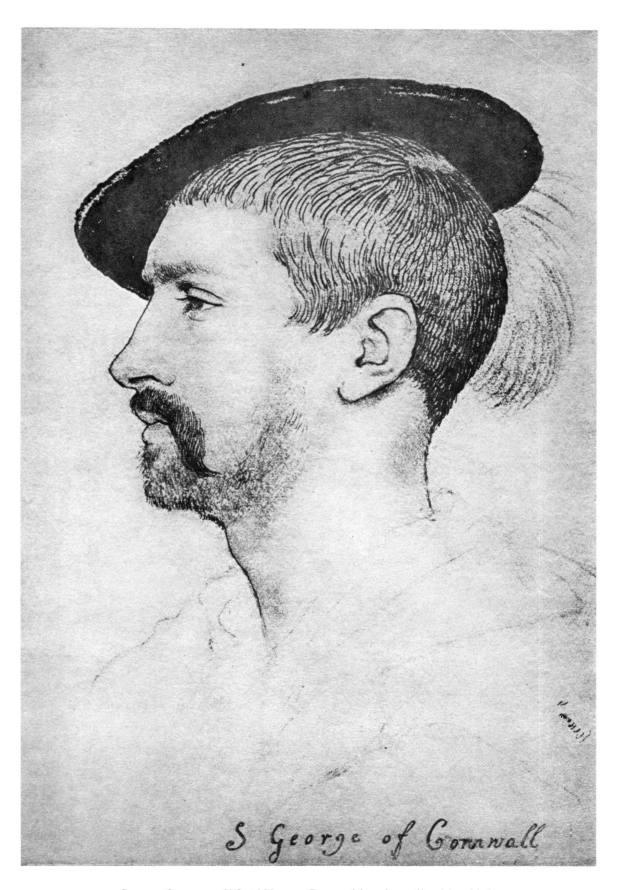

S George of Cornwall

SIMON GEORGE. 279 × 191 mm. Pen-and-brush application of ink.

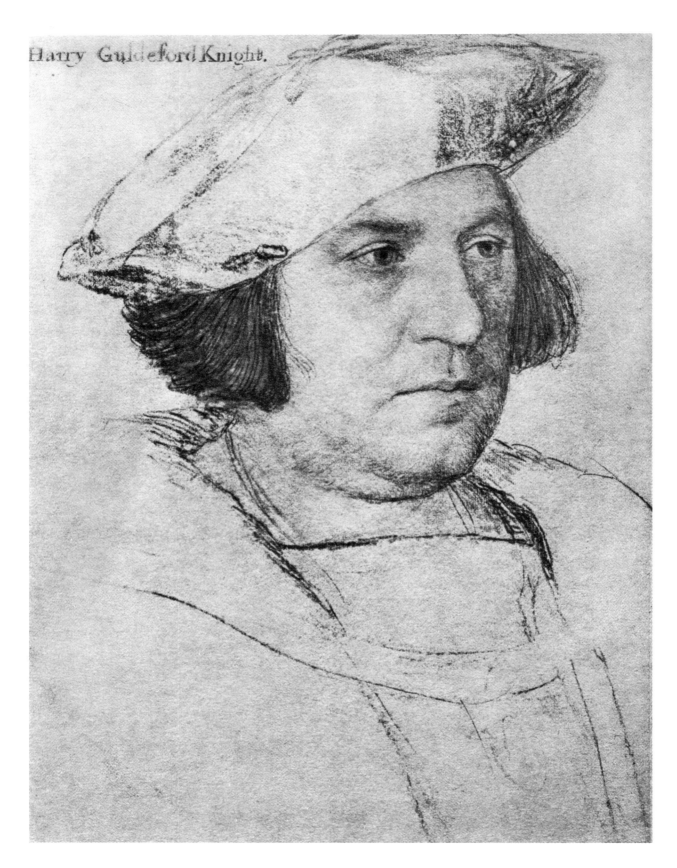

Harry Guldeford Knight.

SIR HENRY GUILDFORD (1478/89–1532). Comptroller of the Royal Household;
Chamberlain of the Exchequer. 384 × 294 mm. Some watercolor.

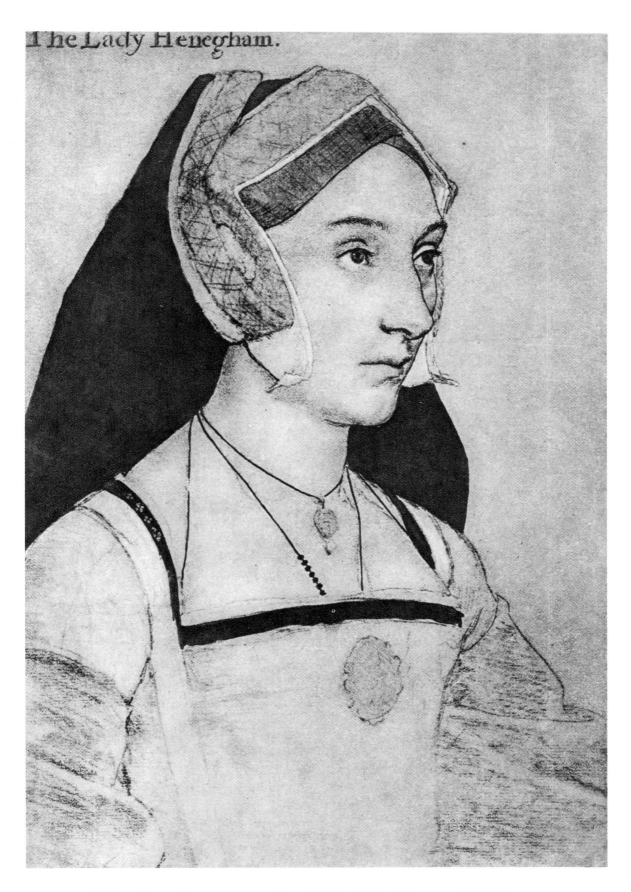

The Lady Henegham.

? MARY, LADY HEVENINGHAM (d. ca. 1563). A lady of the court. 302 × 209 mm.
Pen-and-ink reinforcement of outlines; brush and wash; white heightening.

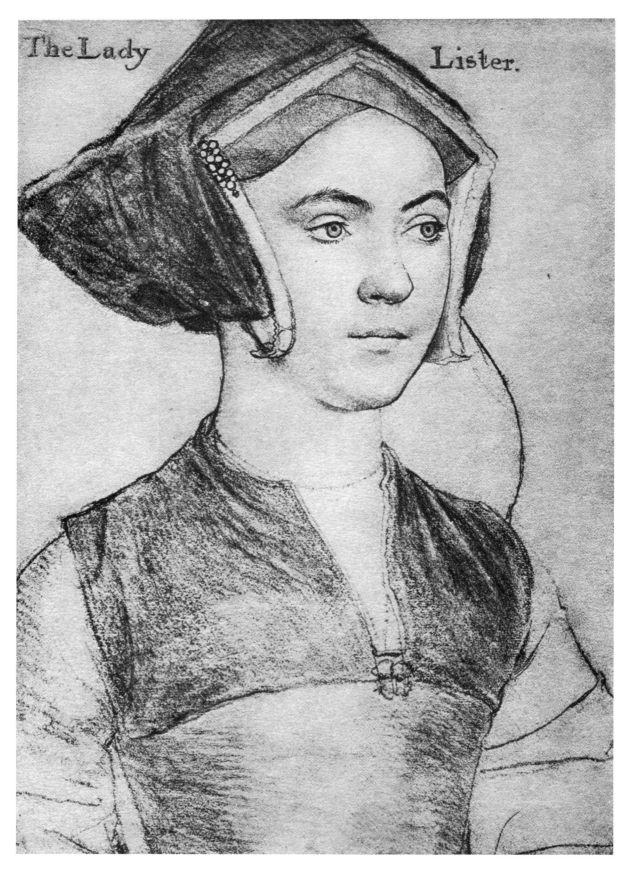

LADY LISTER.

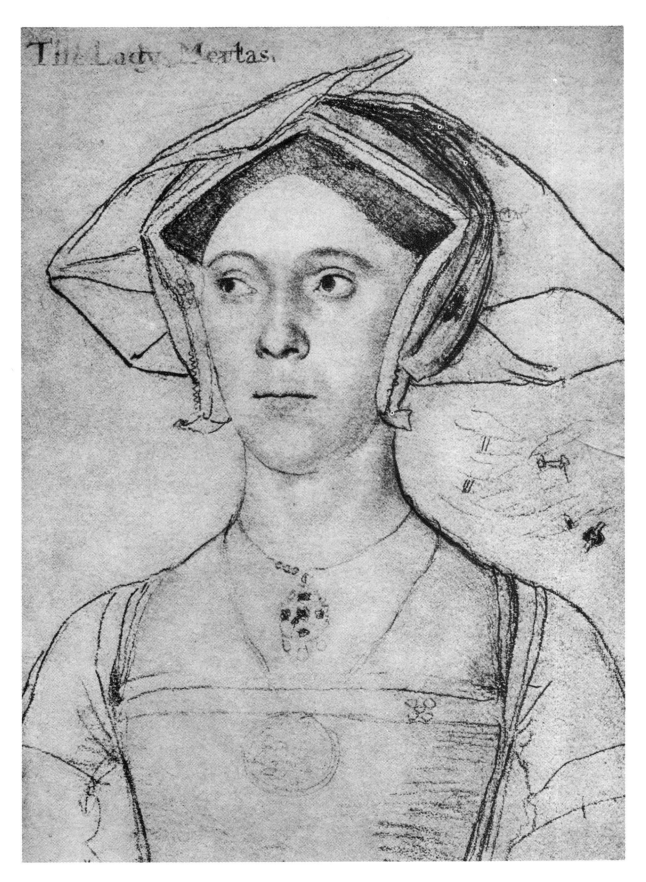

LADY MEAUTAS.

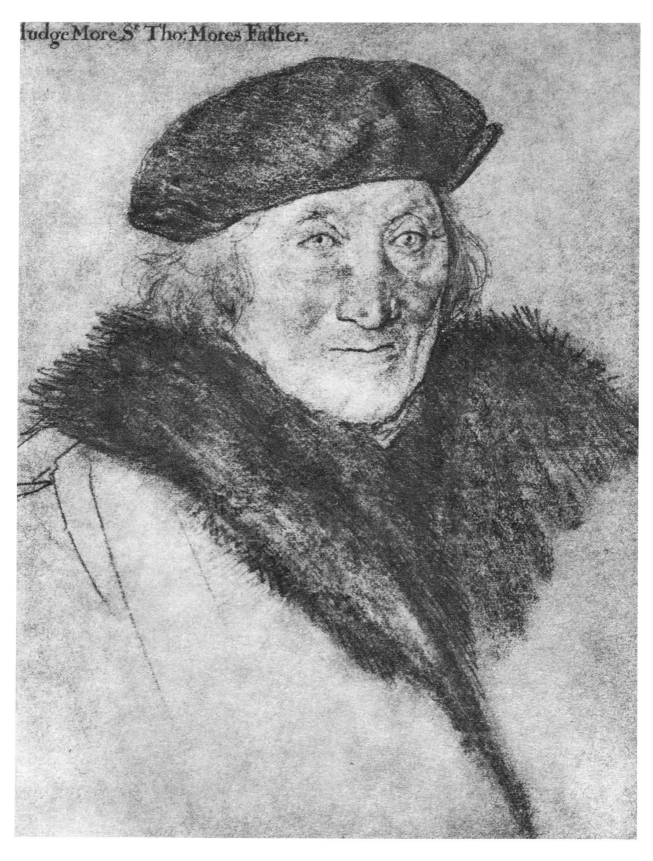

SIR JOHN MORE (ca. 1451–1530). Judge; father of Sir Thomas More. 350×273 mm. Watercolor wash.

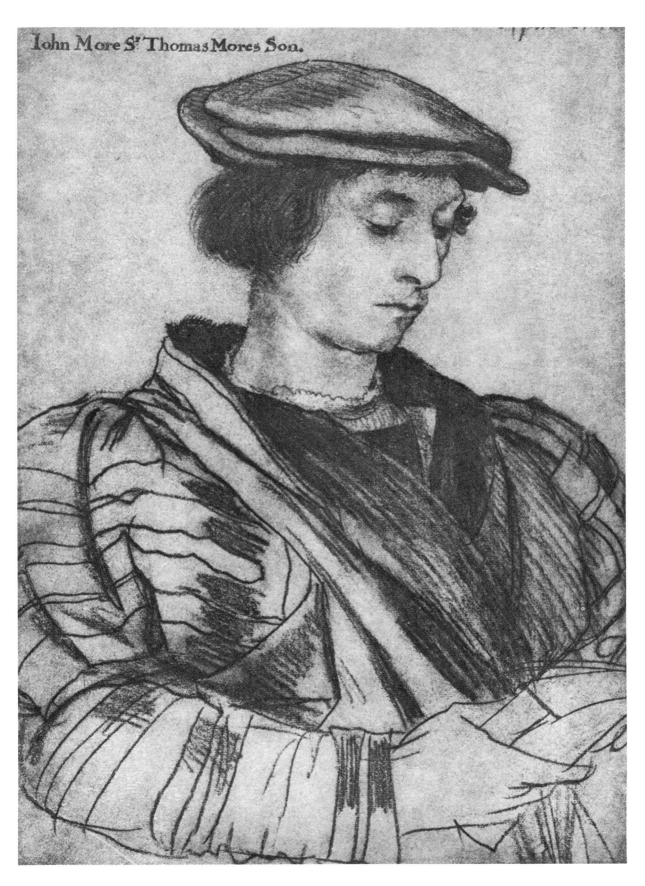

Iohn More S.ᵗ Thomas Mores Son.

JOHN MORE THE YOUNGER (ca. 1509–1547). Son of Sir Thomas More.
380 × 281 mm.

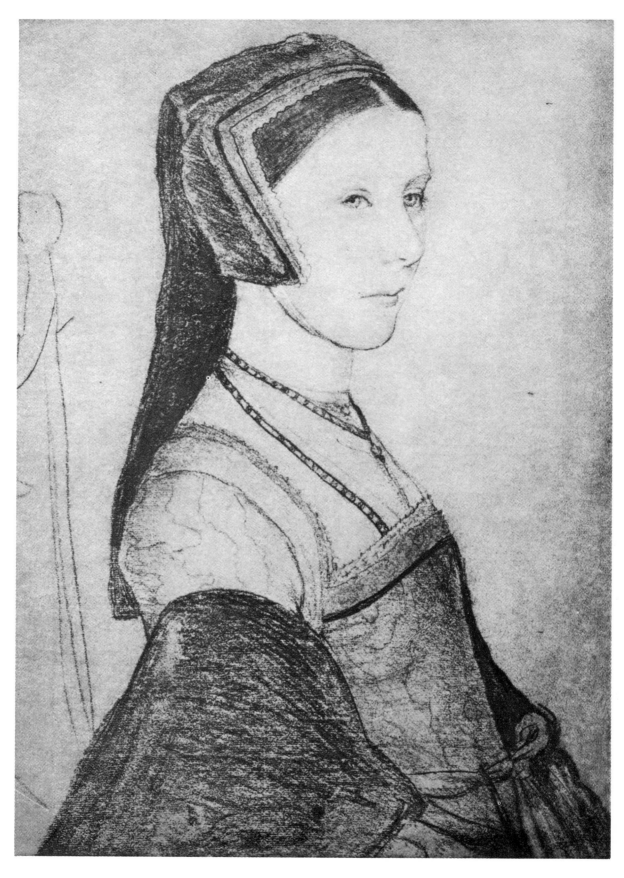

ANNE CRESACRE (1512–1577). Ward of Sir Thomas More; wife of John More the Younger. 379 × 269 mm.

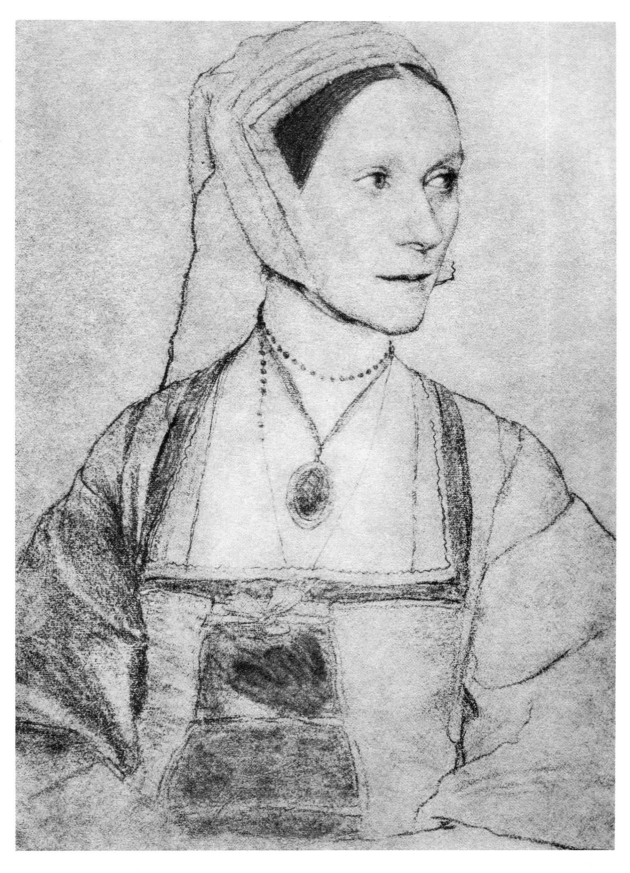

CECILY HERON (1507–?). Daughter of Sir Thomas More; wife of Giles Heron, Treasurer of the Chamber. 378 × 281 mm.

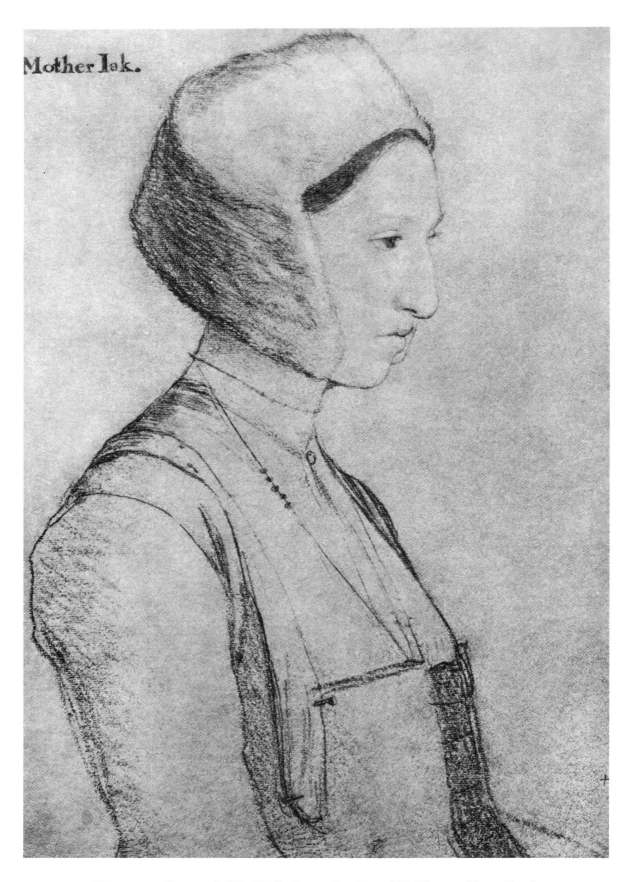

Mother Iak.

MARGARET GRIGGS (1508–1570). Foster daughter of Sir Thomas More; Greek scholar. 379 × 269 mm.

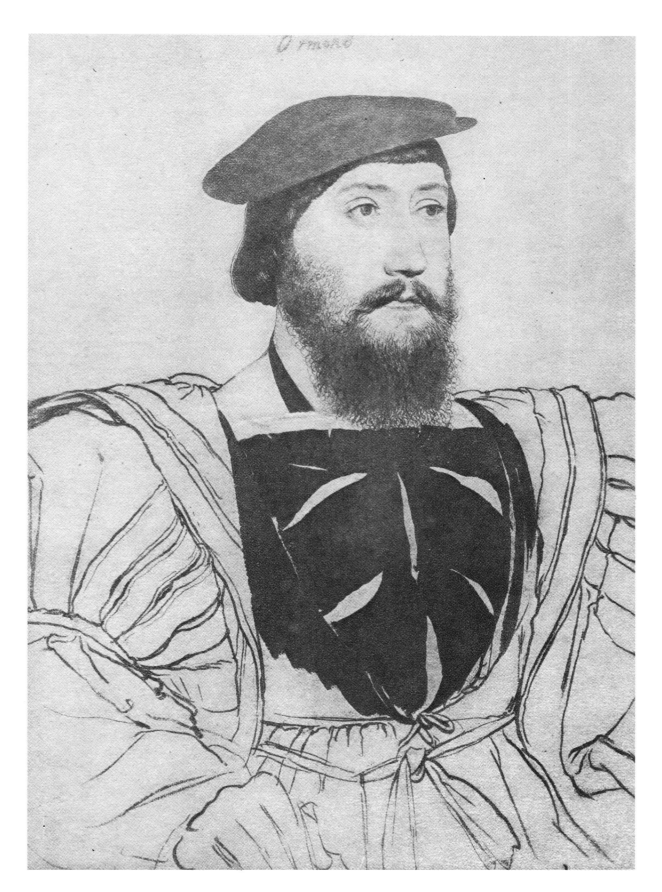

THOMAS BOLEYN, 1st Earl of Wiltshire and Ormonde (1477–1539). (Also identified as James Butler, Earl of Ormonde.) Father of Anne Boleyn; Treasurer of the Royal Household; Lord Privy Seal. 401 × 292 mm. Watercolor and ink applied with pen and brush.

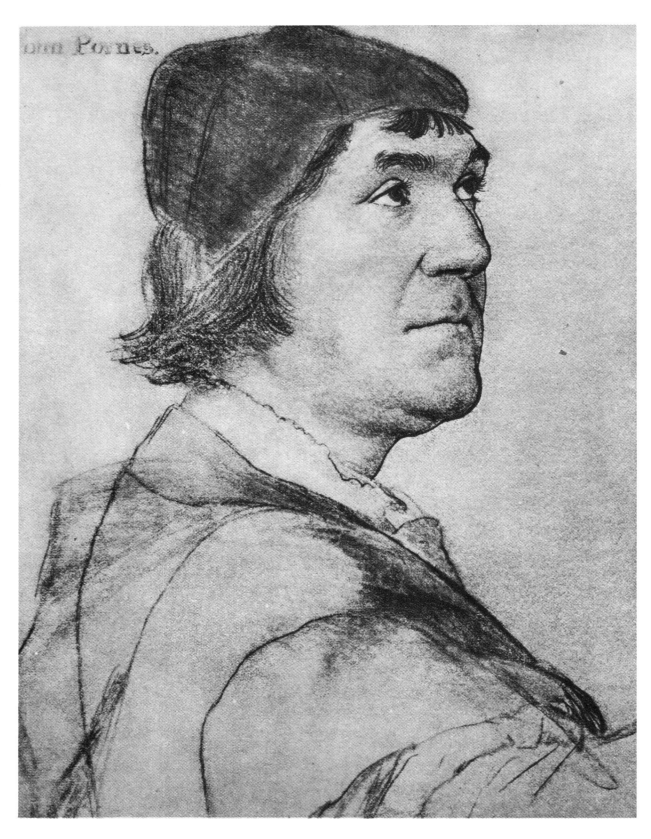

JOHN POYNTZ (d. 1544). Courtier. 295 × 233 mm. Pen-and-ink reinforced outlines.

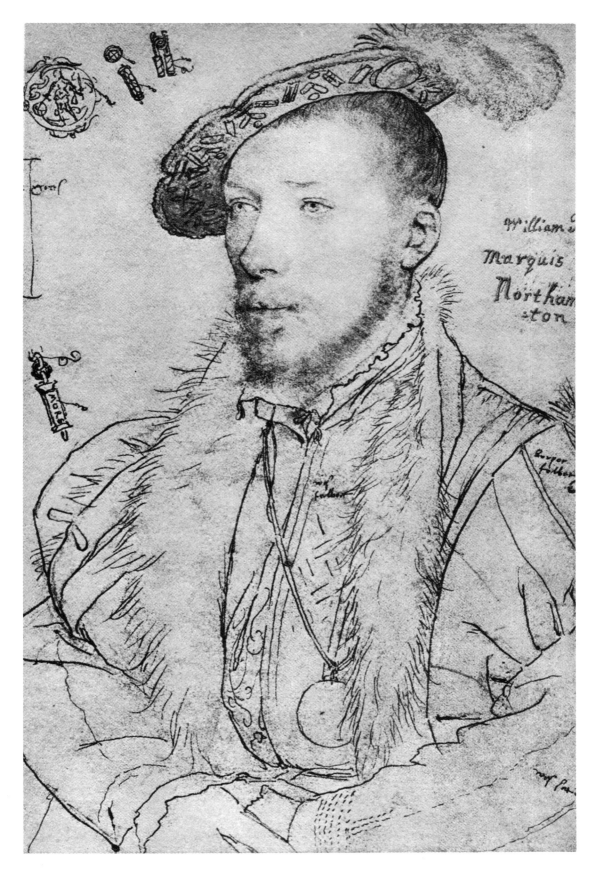

WILLIAM PARR, 1st Marquis of Northampton (1513–1571). Brother of Catherine Parr; Privy Councillor; Lord Great Chamberlain. 316 × 211 mm. Pen-and-brush ink strengthening; white heightening in eyes.

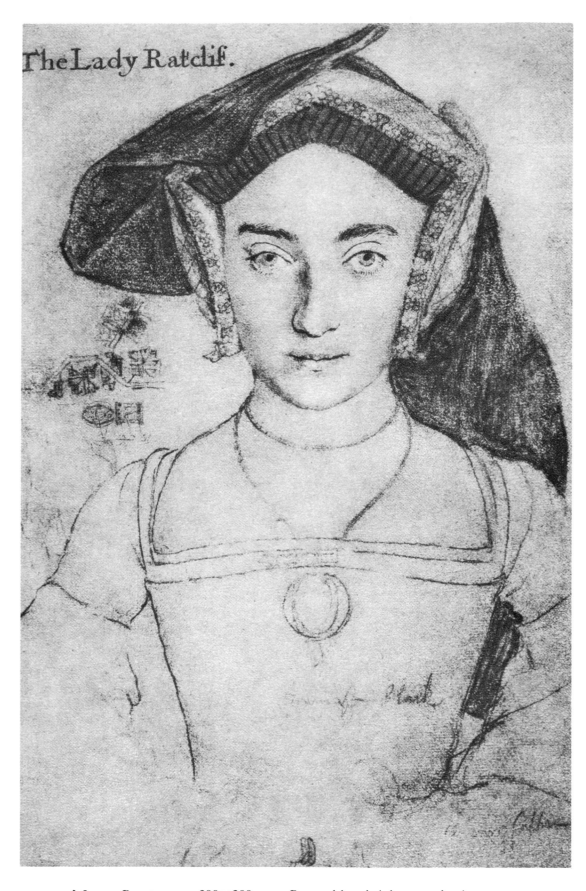

? LADY RATCLIFFE. 299 × 200 mm. Pen-and-brush ink strengthening; some jewelry details in metalpoint.

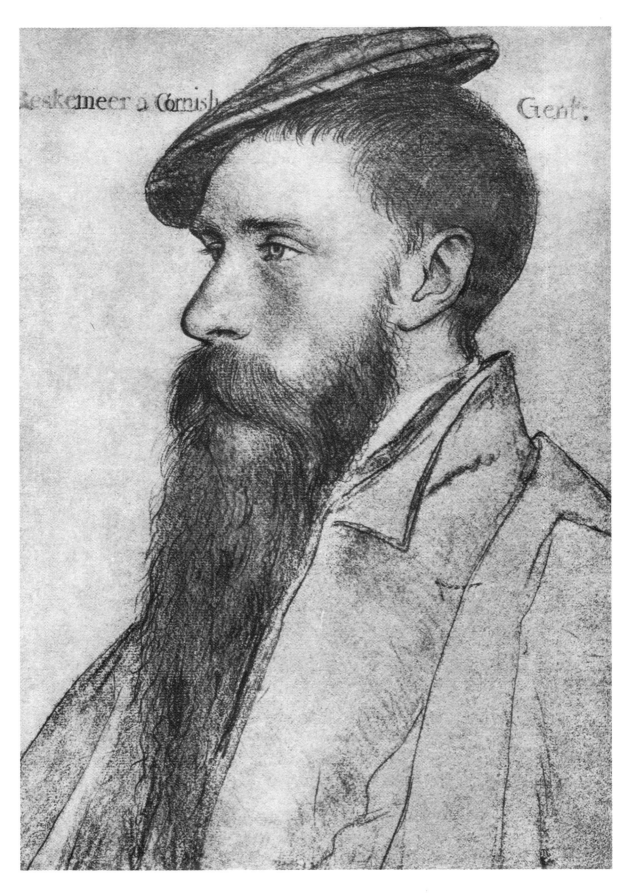

WILLIAM RESKIMER (d. before 1564). Page of the Chamber; Gentleman Usher. 290 × 210 mm. Some metalpoint in costume.

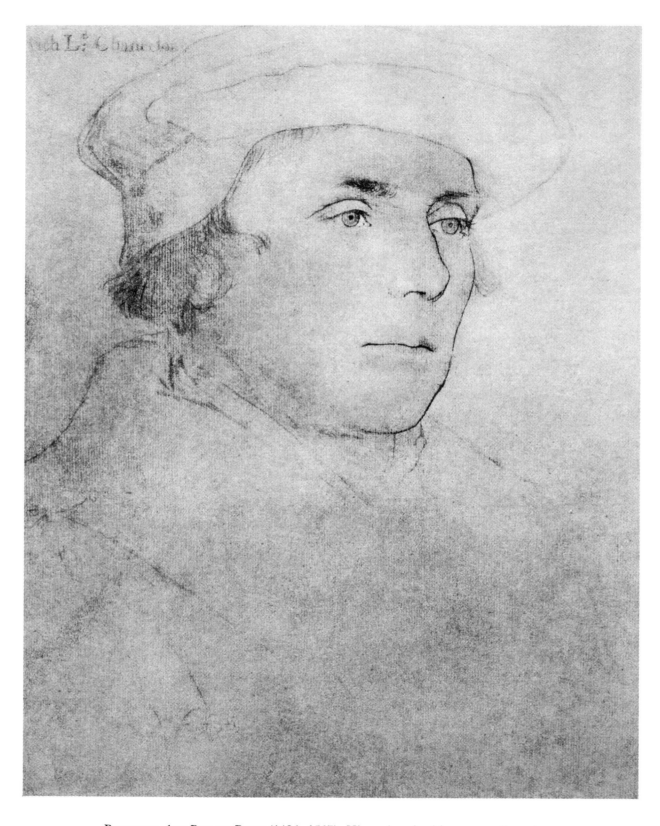

RICHARD, 1ST BARON RICH (1496–1567). His perjured evidence contributed to the condemnation of Sir Thomas More; Lord Chancellor to Edward VI. 320 × 261 mm. Some pen-and-ink reinforcement.

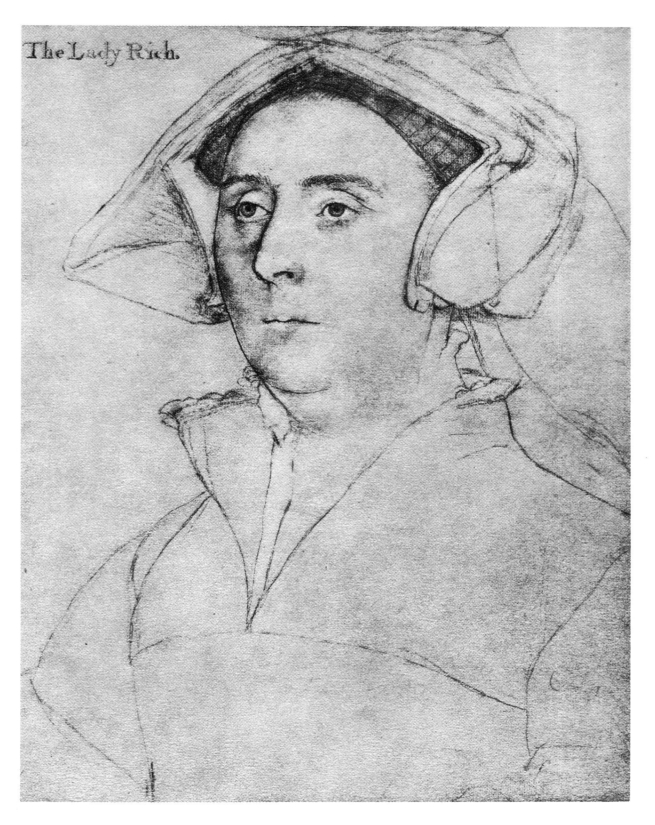

The Lady Rich.

ELIZABETH, LADY RICH (d. 1558). Wife of Richard, Baron Rich; mother of 15 children. 374 × 200 mm. Some pen-and-ink reinforcement.

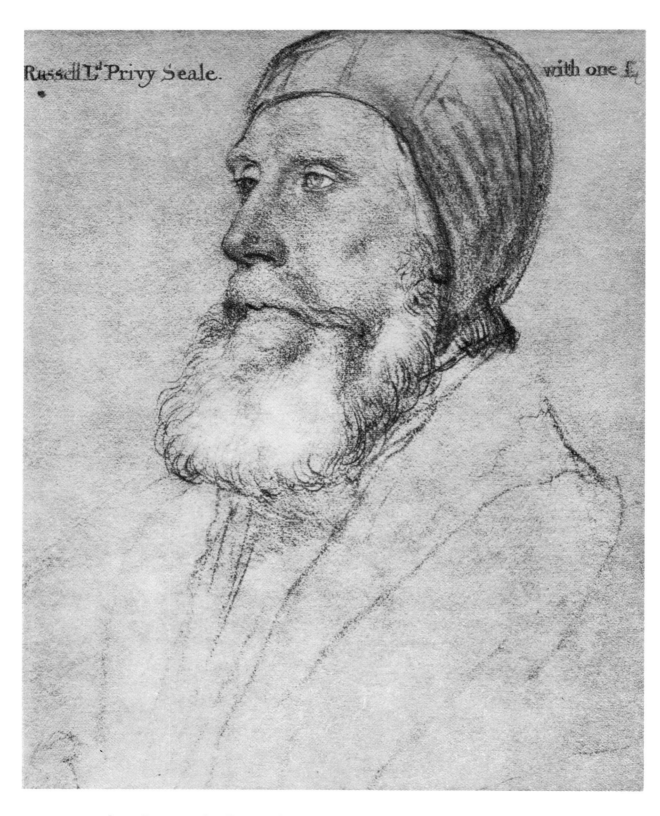

Russell L.^d Privy Seale. with one £

JOHN RUSSELL, 1ST EARL OF BEDFORD (ca. 1486–1555). Diplomat; Lord High
Admiral; Lord Privy Seal. 348 × 292 mm. White body color in eyes.

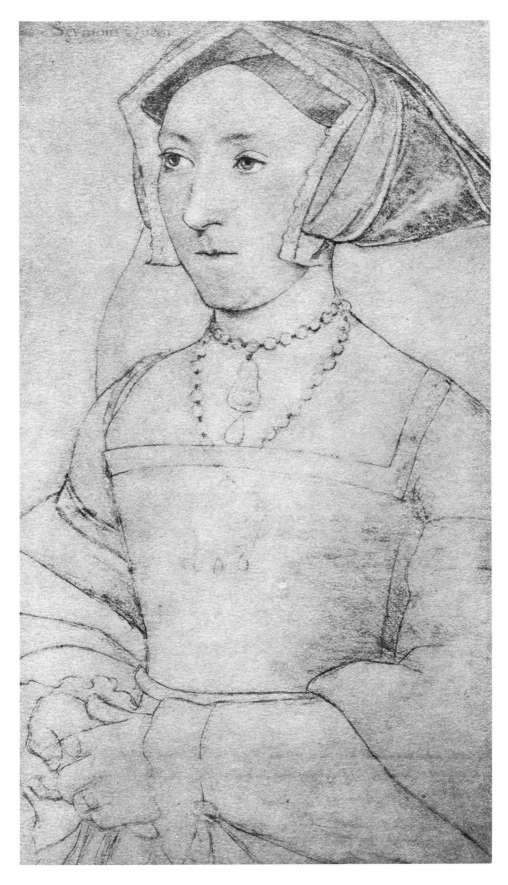

QUEEN JANE SEYMOUR (ca. 1509–1537). Lady-in-waiting to Katherine of Aragon and Anne Boleyn; third wife of Henry VIII; mother of Edward VI. 500 × 284 mm. Pen-and-ink reinforcement of outlines; metalpoint on clothes and headdress.

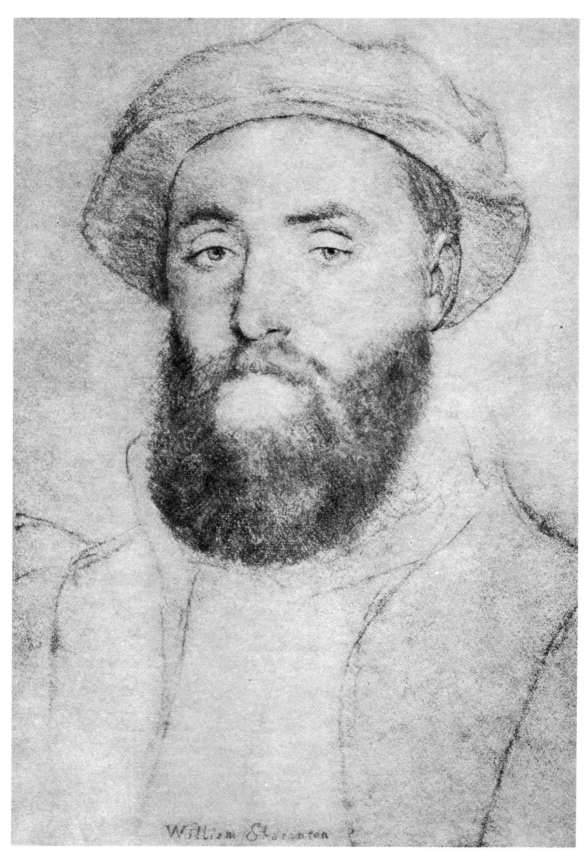

SIR WILLIAM SHARINGTON (ca. 1493–1553). Vice-Treasurer of the Mint,
Bristol; embezzler; Sheriff of Wiltshire. 301 × 202 mm.

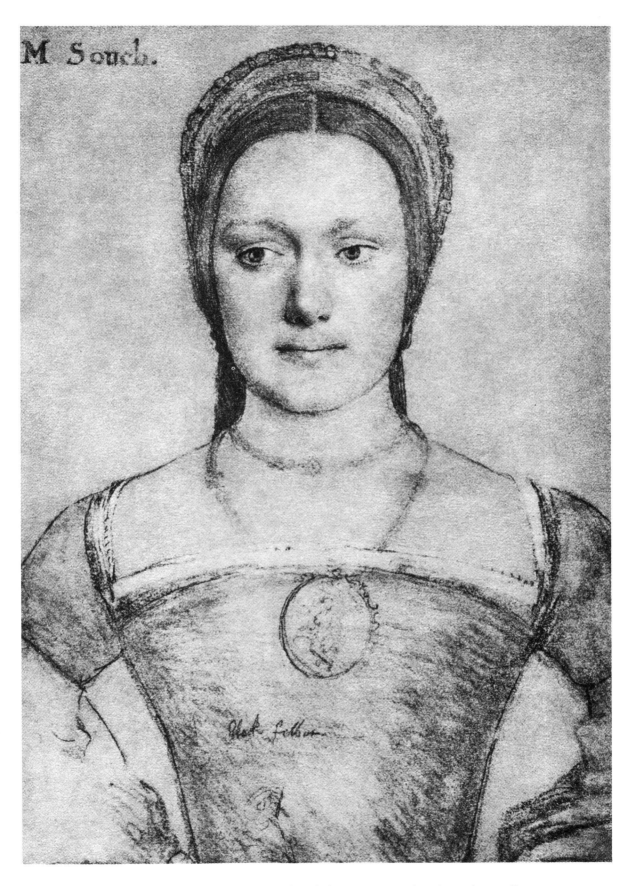

MARY ZOUCH (d. ca. 1532). Lady of the court; rendered service to Jane Seymour. 294 × 201 mm. Some brush-and-ink strengthening of outlines.

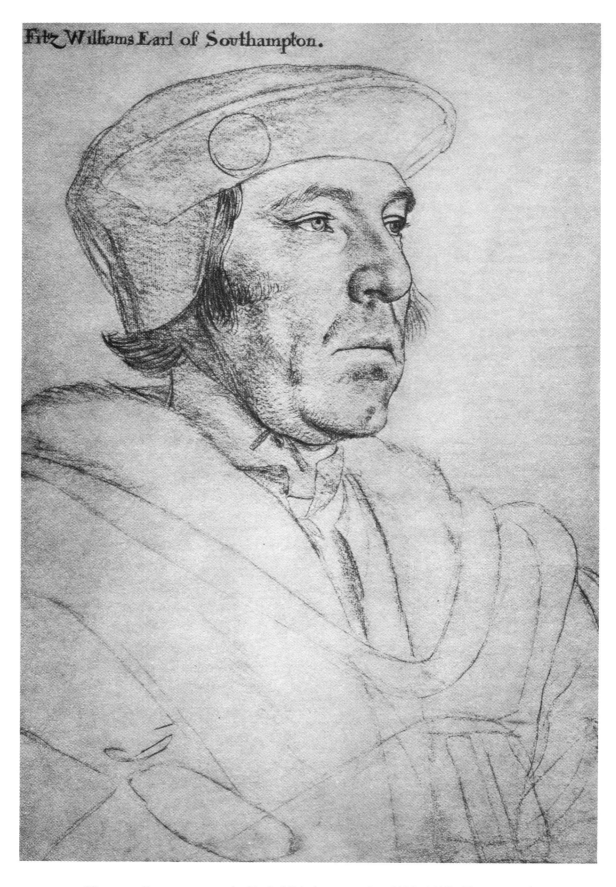

WILLIAM FITZWILLIAM, 1st Earl of Southampton (ca. 1490–1542). Treasurer of the Royal Household; Lord Privy Seal; Lord High Admiral. 383 × 270 mm. Outlines worked over in metalpoint.

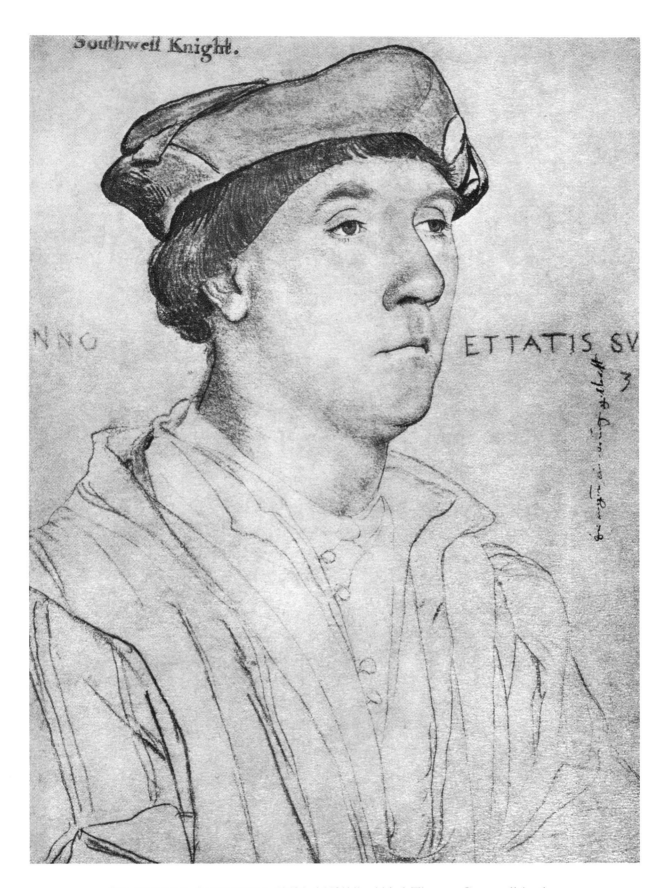

SIR RICHARD SOUTHWELL (1504–1563/64). Aided Thomas Cromwell in the suppression of the monasteries; accuser of Henry Howard, Earl of Surrey; member of the Privy Council under Edward VI and Mary. 366 × 277 mm. Ink outlines.

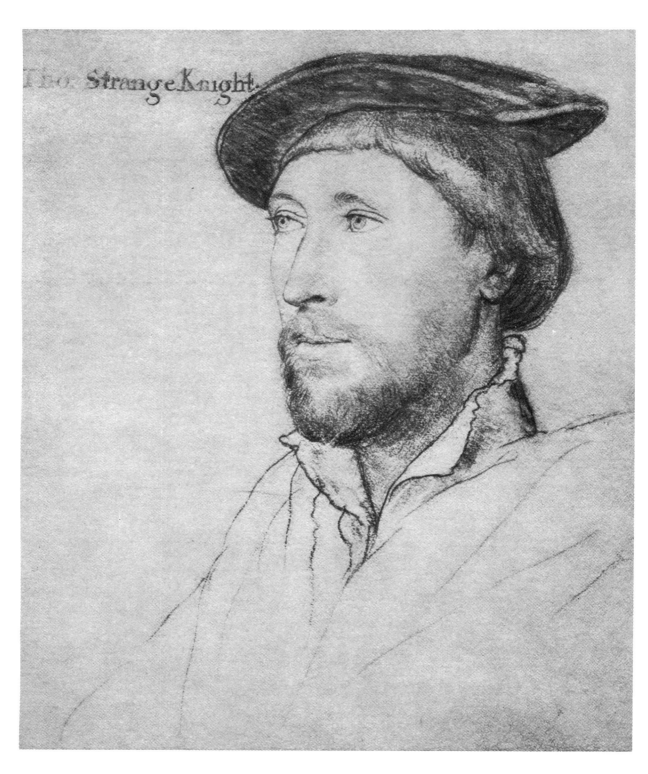

SIR THOMAS STRANGE (1494–1545). Esquire of the Body to Henry VIII;
Sheriff of Norfolk. 243 × 210 mm.

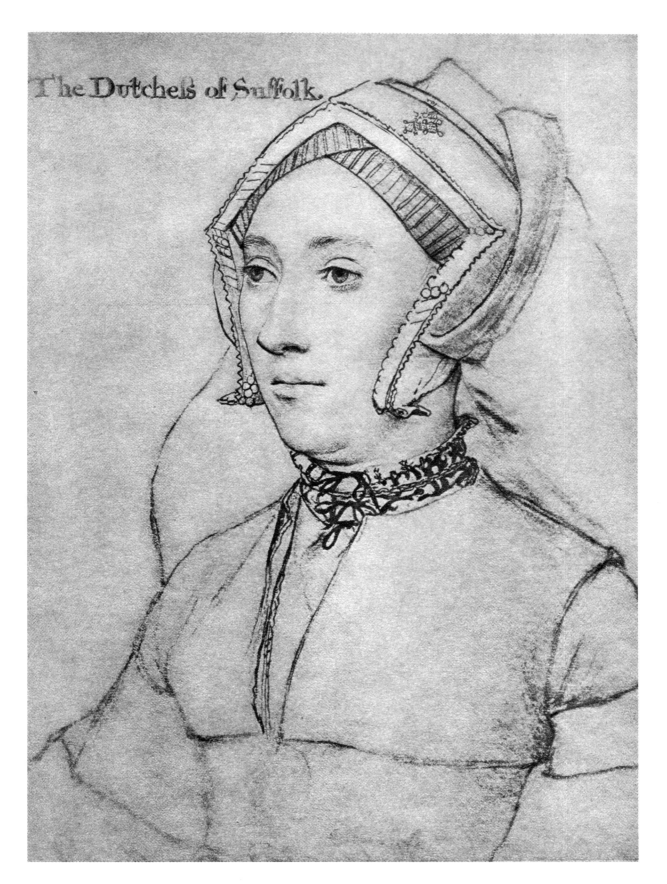

? CATHERINE, DUCHESS OF SUFFOLK (ca. 1519–1580). Fourth wife of Charles Brandon, 1st Duke of Suffolk; fled England with her second husband during Queen Mary's persecutions. 289 × 209 mm. Some pen-and-ink reinforcement of outlines.

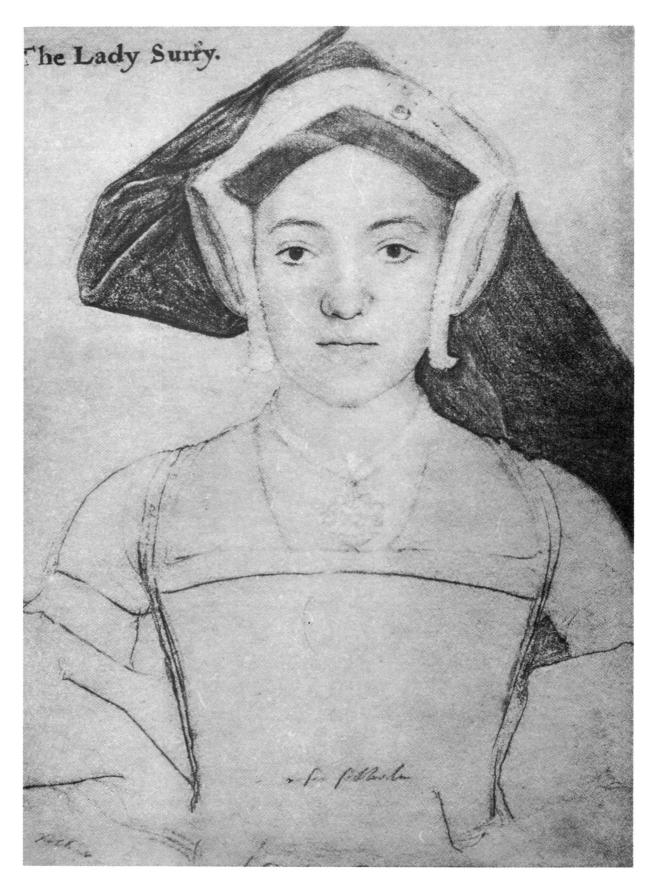

The Lady Surry.

FRANCES, COUNTESS OF SURREY (1517–1577). Wife of Henry Howard, Earl of Surrey. 310 × 230 mm. Pen-and-ink strengthening of outlines; some body-color heightening.

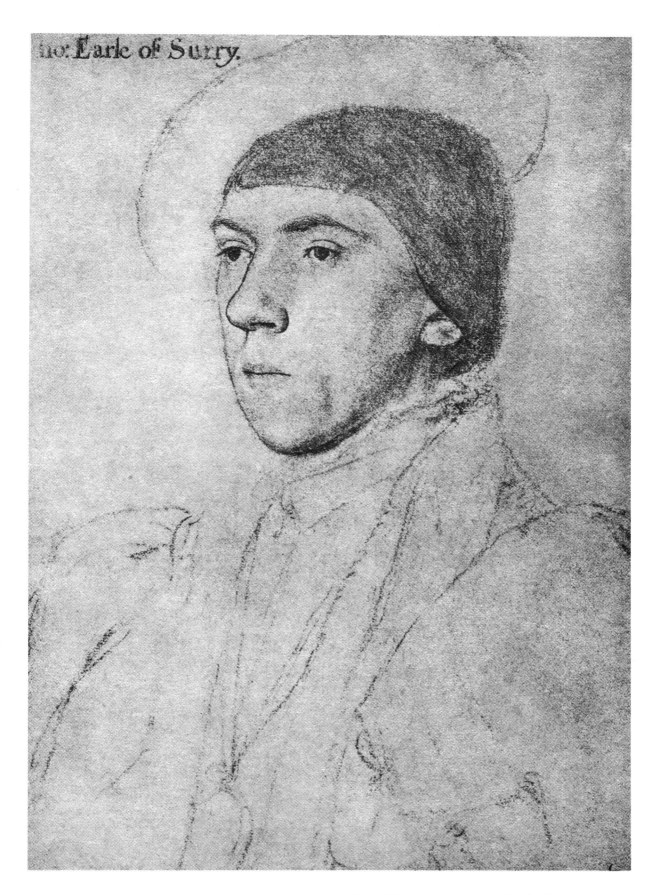

HENRY HOWARD, EARL OF SURREY (ca. 1517–1547). Poet; translated Books II and IV of the *Aeneid* and adapted Petrarch's sonnets; executed 1547. 287 × 210 mm. Pen-and-ink strengthening of outlines.

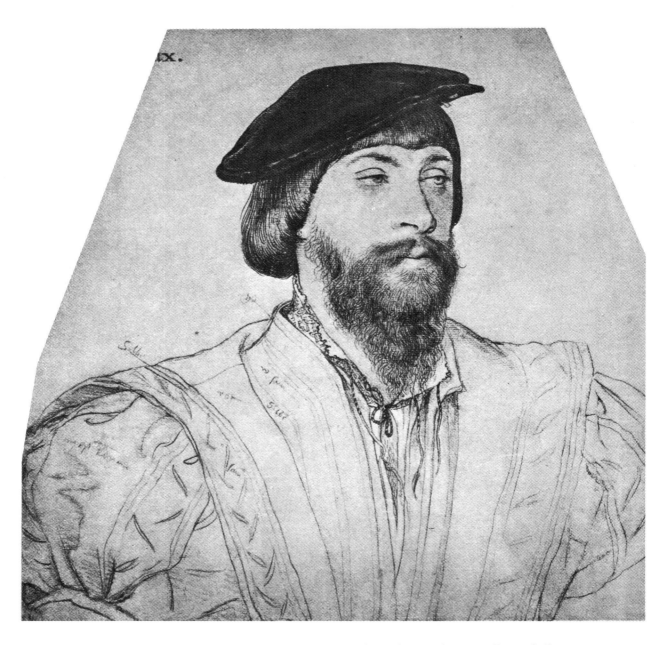

THOMAS, 2ND BARON VAUX (1510–1556). Served on embassy to François I; Governor of the Isle of Jersey; poet. 277 × 292 mm. Some watercolor with body color and pen-and-brush ink strengthening.

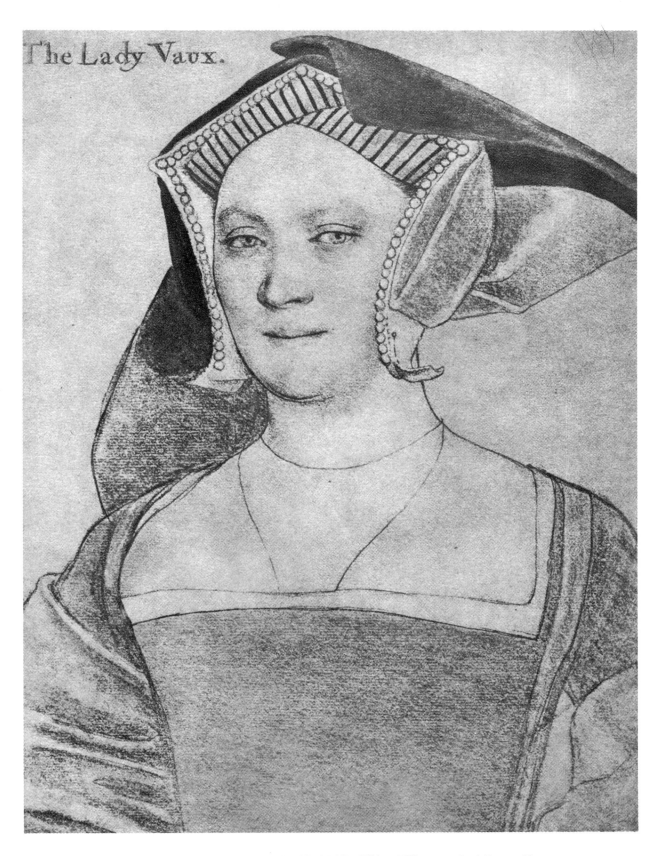

The Lady Vaux.

ELIZABETH, LADY VAUX (1505/09–1556). Wife of Thomas, 2nd Baron Vaux.
279 × 212 mm. Some pen-and-brush ink reinforcement, some white body-color
heightening; outlines gone over in metalpoint.

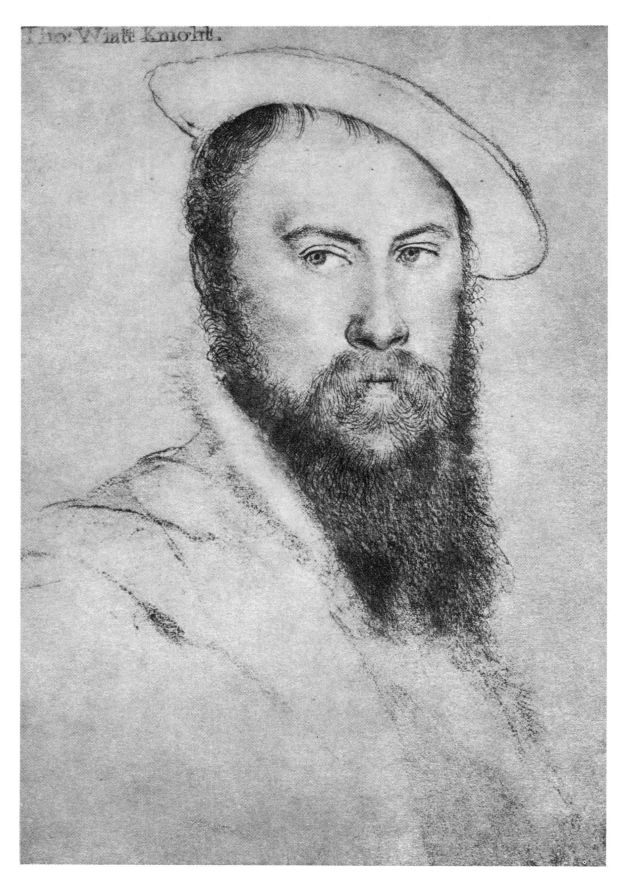

SIR THOMAS WYATT (ca. 1503–1542). Diplomat; poet; translator of Petrarch's sonnets; probable lover of Anne Boleyn. 371 × 270 mm. Pen-and-brush ink reinforcement.

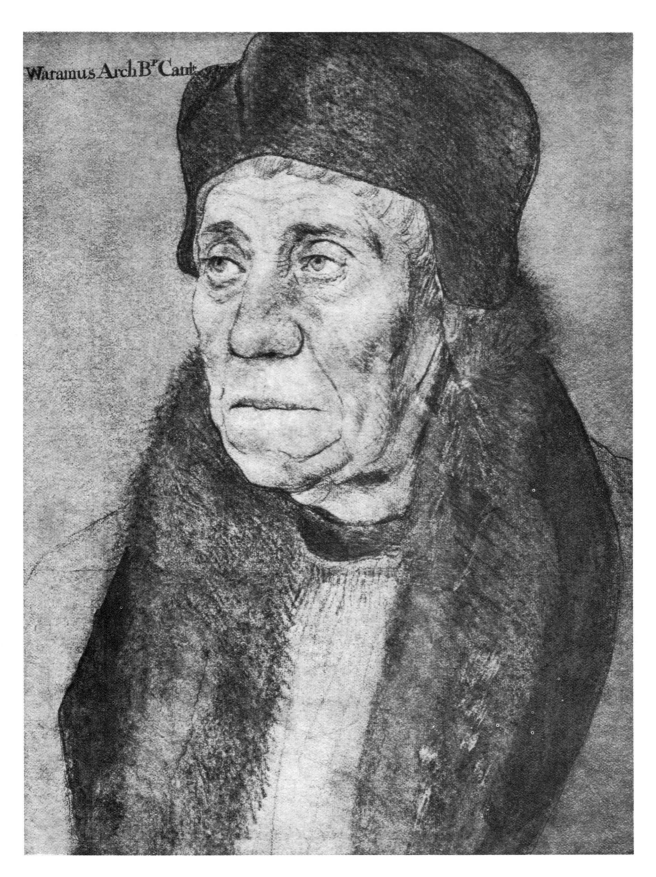

WILLIAM WARHAM, Archbishop of Canterbury (1450/65–1532). Bishop of London; Lord Chancellor; patron of Erasmus. 407 × 310 mm. Some wash.